# MANSCAPE WITH BEASTS

# MANSCAPE WITH BEASTS

## PHOTOGRAPHS BY BARBARA NORFLEET

HARRY N. ABRAMS, INC., PUBLISHERS, NEW YORK

For Andy, Caitlin and Alex

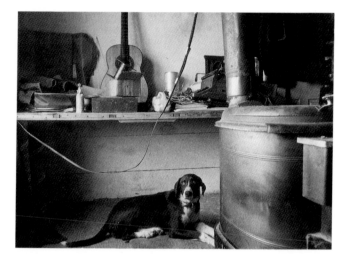

*Sweet Bitch,* 1968

It happened on a soggy fall Friday night. I was four, the year was 1930. My mother, my father, my sister, and I had moved from a place I loved to live with my grandparents in a town I hated and continued to hate for the eleven years we were forced to remain there. There was not much to do in that Depression-ridden town, and that small house held so many people that family friction and affection took up all available energy and time. That night Bubbles, my collie dog, was hit by a car. The precise image I carried with me for thirty-seven years was of Bubbles flat out on a table, his beautiful golden grace fallen in, a few wet leaves sticking to his side, my parents weeping without end over his body. For years I felt that they had shown poor judgment to display such uncontrolled grief in front of me, a small child. After I had small children of my own their emotional behavior rankled; and thirty-seven years after Bubbles' death, I confronted them and learned the truth.

My mother said, "But, Bobbie, you were the one who was inconsolable. You cried for three days and nothing your father or I could do would comfort you."

This story isn't offered to show the tricks of memory, but to show how I felt about animals from a very early age.

A few other tales as I see them now.

I see Mac, my pet crow, stalking arrogantly through our tight house, and stealing my cherished charm bracelet. The tiny gold king of hearts, the bicycle with moving wheels, the glass cube with a dollar bill folded inside, and the other six charms represented nine birthdays. I see myself crossing our backyard, the sun-heated cinders hurting my bare feet, and facing up to Mac at the entrance to his red clapboard house perched high on our garage. I feel the courage it took to thrust my hand to the very rear, evading Mac's burnished black body, to grab it back. The next day Mac

joined the wild crows. Intent upon not losing a good thing, Mac scolded us awake each morning until we fed him and his companions.

Mac was neither cute nor affectionate, but we respected him. I'm the only person I know who likes crows.

Returning from a night out I see the house strewn with torn papers. Thump, the rabbit, got to Fred, my husband, just where it hurt. This was her traditional answer to being left alone. Thump grew up at my children's school in a small cage. We offered to take her after she had served the school's purpose. We, and our dogs, enlarged our idea of family to include Thump. There was no cage: the dogs gave up their instinct to chase. Thump responded by becoming the leaping, loyal, and trusting animal the school wanted but did not get.

I remember meeting Betty for the first time. It was in 1962. I was in the library of Walter Stone, Director of the Franklin Park Zoo in Boston, reading a book on animal behavior. My children were growing up and I was testing possible careers. Betty jumped in my lap, threw the book I was reading on the floor, and shook hands with me. Not bad for a two-and-a-half-year old orangutan.

Betty was given to trickery. I'll play one episode out. One day when I arrived to work with Betty she was for the first time not free but in a large cage sitting right in the middle of an empty room. A cage with bars closer together on the sides than on the top. I had chosen to bring three things that morning: a complex toy of separate parts, whose many shapes fitted into different holes; a toy with many knobs that performed different things when turned, but that stayed in one piece; an outgrown pair of one of my own toddler's corduroy overalls. Cloth was a constant gift because Betty always jumped around in excitement when she saw it, grabbed for it, hugged it, stroked it. A premonition of Betty choking on the complex toy of many parts led to second thoughts about my giving it to her. I placed it out

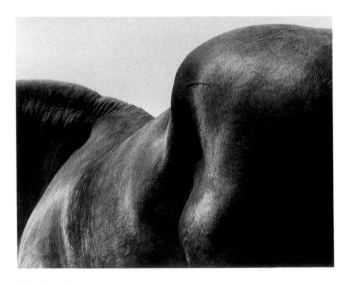

*Nude Horse, 1970*

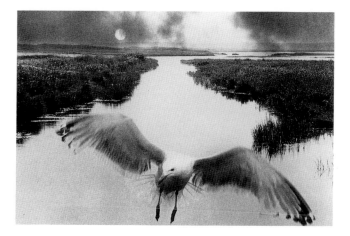

*Seagull, 1974*

of the reach of her long arms and we spent the morning with the overalls and simpler toy. Betty attended only to me, or so it seemed.

As I was preparing to return home I turned away from Betty to keep from responding to her somersaults and clapping, antics she performed to seduce me into never ever leaving her. With a spirited dash across the cage Betty thrust the overalls out of the bars, holding onto the bottom of one leg, thrust her other hand through the bars and grabbed the bottom of the other leg, lassoed the forbidden toy with the crotch, and pulled it toward the cage. She never even tried to get it through the side bars. It would not have fitted. She worked it up to the top with her two hands outside the bars, and brought it in through the widely spaced top bars. So much for animals not being able to plot, plan, or deceive. Betty anticipated that at some moment I would look away and she had her plan ready.

I have a clear memory of our bushbaby Seymour, an enormous-eyed tiny mammal related to monkeys. After "he" produced a baby we changed her name to See-More. All ages and sexes wanted to caress See-More. She was so beautiful and looked so lovable. She in turn regarded people as the enemy and tried to bite them if they cornered her. Smuggled to me from the Kalahari in an anthropologist's pocket, she was a gift I never wanted.

I gave her her own room. I put a tree in it. I learned how to raise mealworms to feed her. See-More forever greeted me with appropriate hostile hisses. I winced all night listening to her unending painful cries. For freedom? For another bushbaby? At last she bit through the sashcord and escaped. I doubt that she found what she wanted in Cambridge.

Dogs are different from other animals. Ours have never relished freedom, privacy, or independence. They attached themselves to us before each was entirely a dog. They became what we wanted them to be. Fred says a dog is the only way you can buy love with money. I have often wondered why they give up their dogginess for us. People who do not want

the bother of a dog borrow our dogs when they take the family picture for the photograph album. They know future generations will think more kindly of them if a dog was part of their family.

Harvard, where I work, allows you independence and privacy. You make your own way. Set your own game plan. There is little interference. Such freedom inspires, but it can be lonely. Such freedom can make you feel no one cares. Harvard also allows its faculty to take a free course every year. In an attempt to recreate some of the collegial atmosphere of Swarthmore, where I went to college, I take a different course every year. It has changed Harvard for me. Professors do not know me as they wander about the campus, give speeches at faculty meetings, and hand out quotes to the press. But I know them, what they are doing, what they are telling students, probably what they are thinking.

Len Gittleman's beginning photography course, which I took in 1968, changed my life. I took to the course with passion and hard work, not as a listener like the others. Darkroom photography is magic the first time you do it. It is easy to get hooked. I was a frustrated artist always. Pictures popped up in my mind but I had no ability to draw. Words never came naturally to me. I couldn't find the right ones, the ones that said what I meant: I couldn't order them right. But I saw in that first photography class a chance to leave the world of words and enter the world of images. I was hooked.

Looking back over my own photographs, I realize that a project on animals has been stashed away in my head since I took that course. *Sweet Bitch* was my first favorite photograph. For my final project in that introductory course, I had chosen to photograph a Harvard graduate, Bronie, who had dropped out of the professional mainstream to become an apple picker and maple sugarer in rural New England. This was 1968, and

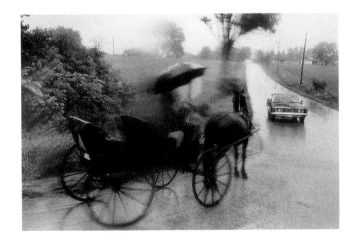

*Indiana 1976*

*Peaches, 1978*

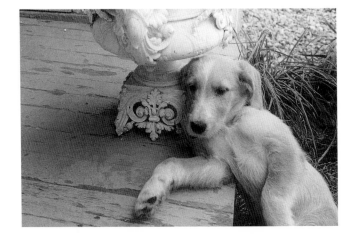

the whole class wanted to be him. Sweet Bitch was his dog. Bronie was picturesque — many hats, old cars, no electricity, bare feet. All the clichés were there for a beginning photography student — nostalgia, eccentricity, weathered wood. But it is the dog who survived.

Next, I studied the big men with big horses who compete pulling big weights at county fairs. After three years I quit this project. The men were just too different from me. I could not empathize either with their attitudes or their values. I could not reciprocate their friendliness. I felt exploitive because I realized I did not like these men. But not so with their horses. *Nude Horse* is the first photograph I made that a museum collected.

My next project was on Tisbury Great Pond and included people, flora, and fauna. *Seagull* is the one image that remained after editing.

In 1976 I crisscrossed America collecting negatives from old studios to set up a photographic archive on the social history of the United States. I took my camera along. America's individualism, freedom, and privacy has created a diversity I did not expect. *Indiana 1976* is how America felt to me.

I did an entire project on *Peaches* when we got her twelve years ago. It was a very personal project. I wanted to take the kind of pictures I was not competent to take when my own children were growing up.

*Cyrus* is a clear forerunner to the body of photographs that forms the substance of this book.

I've told some stories. You see the point. I respect animals. I was raised to believe that life would always get better, but I've lost that certainty.

Barbara Norfleet
May 1989

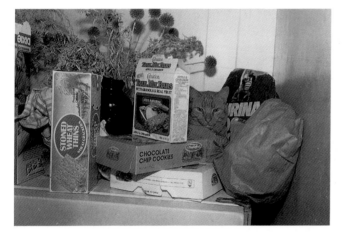

*Cyrus,* 1984

1986
_____

Immature herring gull on car roof

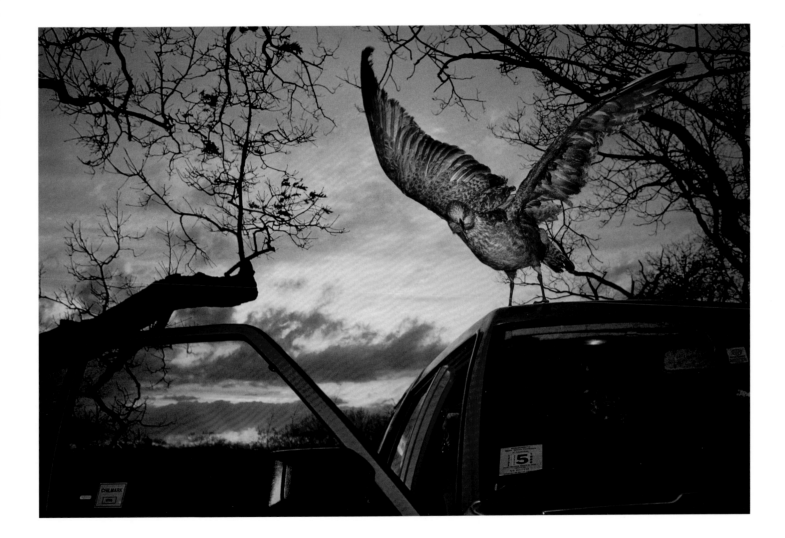

1985
_____

Gray horse and car radio antenna

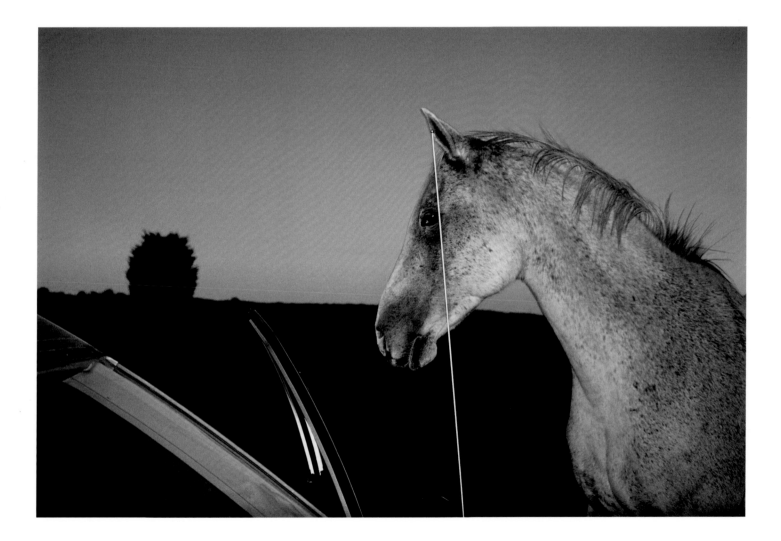

**1984**

Garter snake, wine bottle, and *Wall Street Journal*

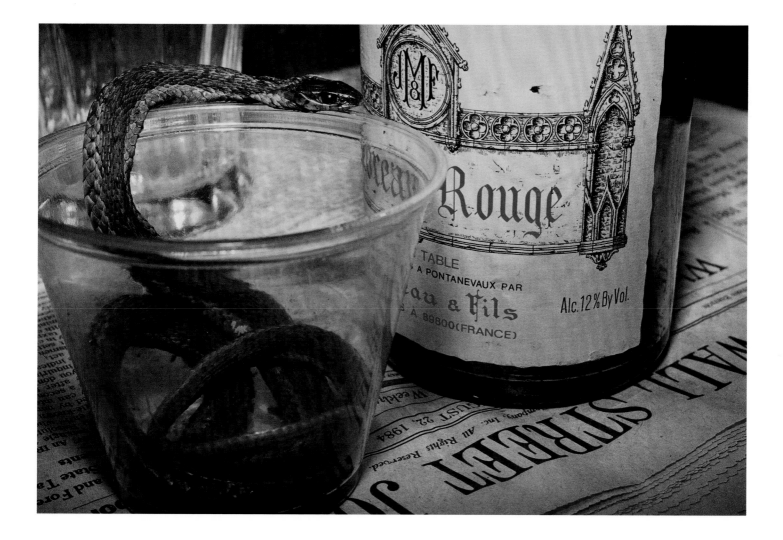

1988
_____

Golden labradors and lawn ornament

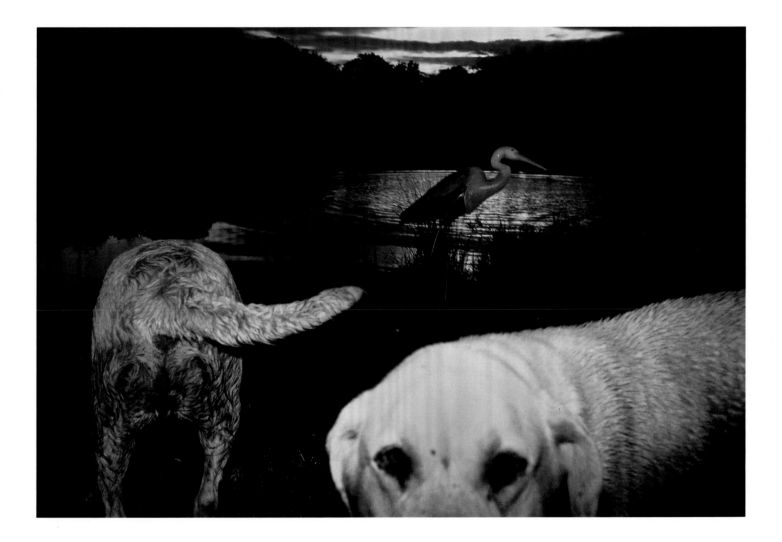

1987
_____

Muscovy duck, farm duck, wood duck, and lawn ornament

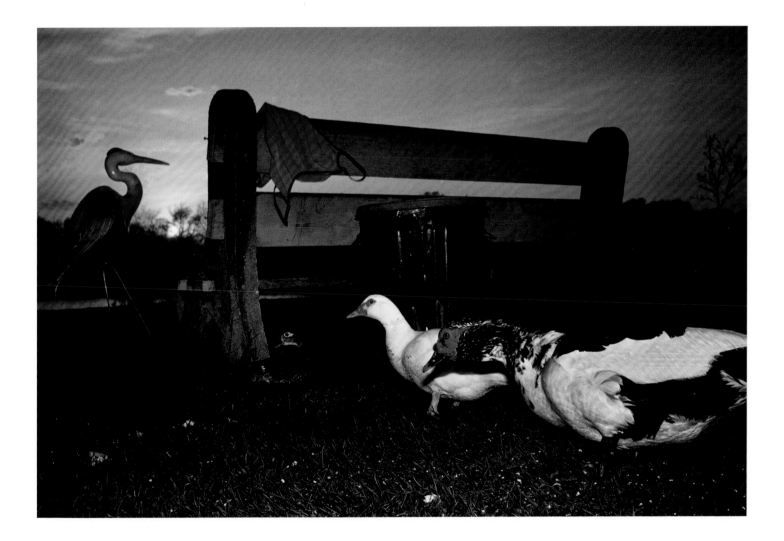

1985

Skunk and strawberries on Great Pond

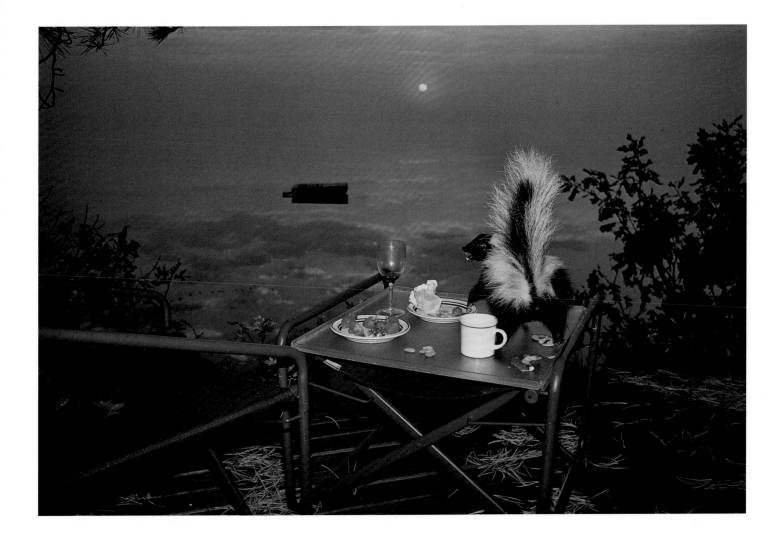

1986
--------------

Brown horse and kitchen counter

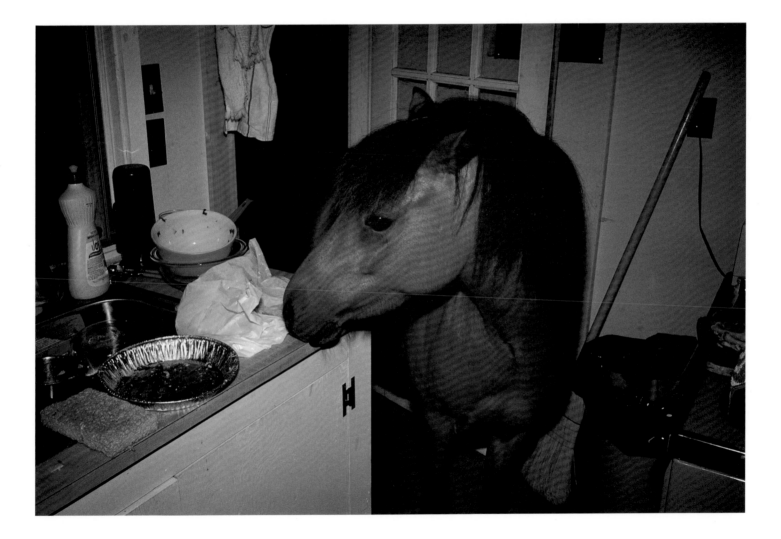

**1985**

Wood rat on table

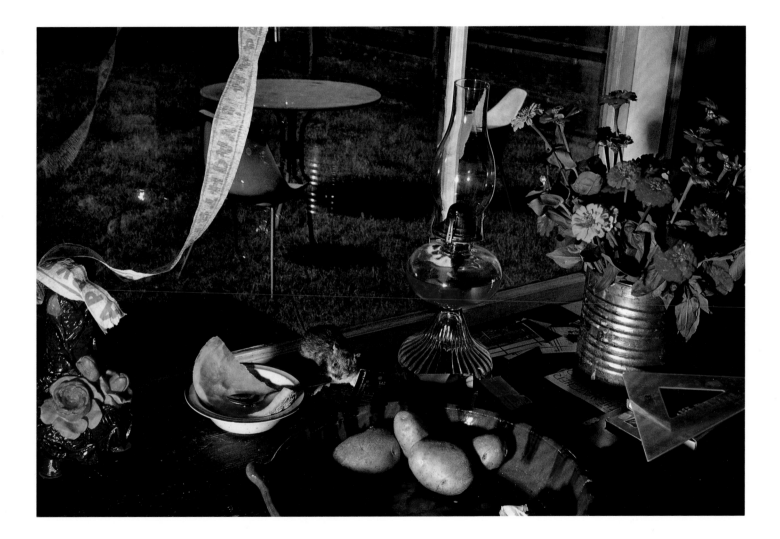

1986
_____
White pigeon and broken wine glass

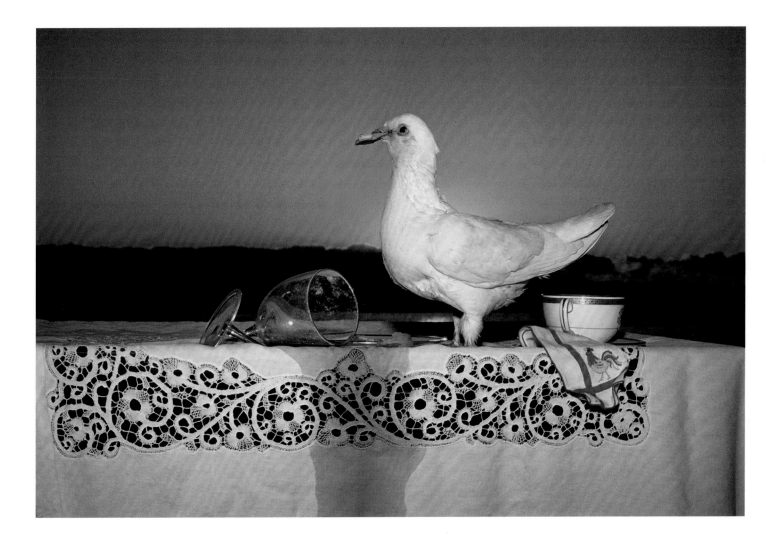

1986
_____
Muskrat and book on Black Point Pond

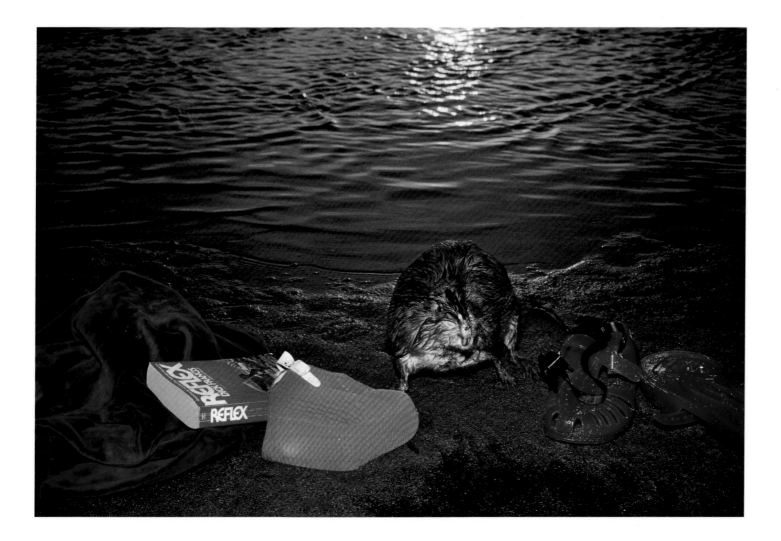

1988
_____

Wood rat and dollhouse family

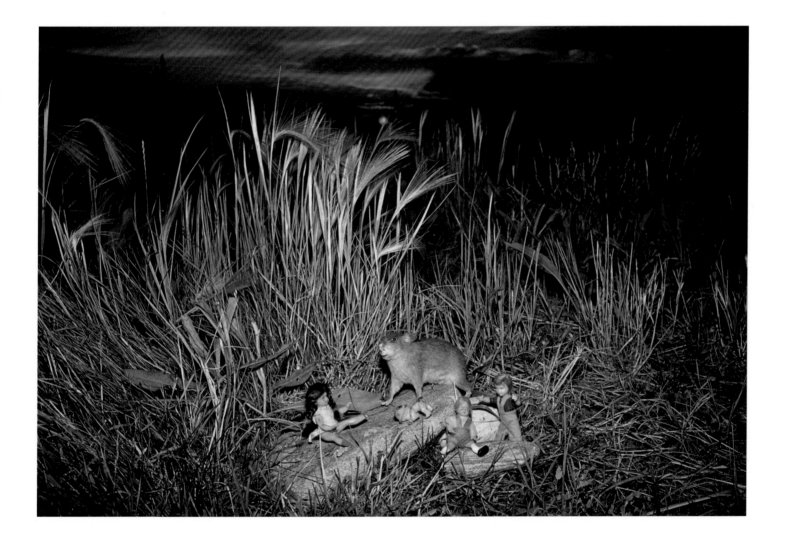

1987
_____
Woodchuck with corn and glove

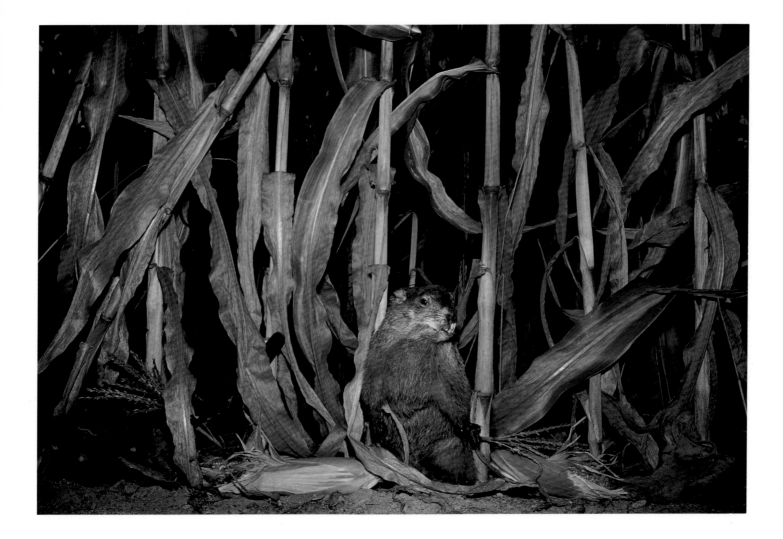

1985
_____

American crow and sign

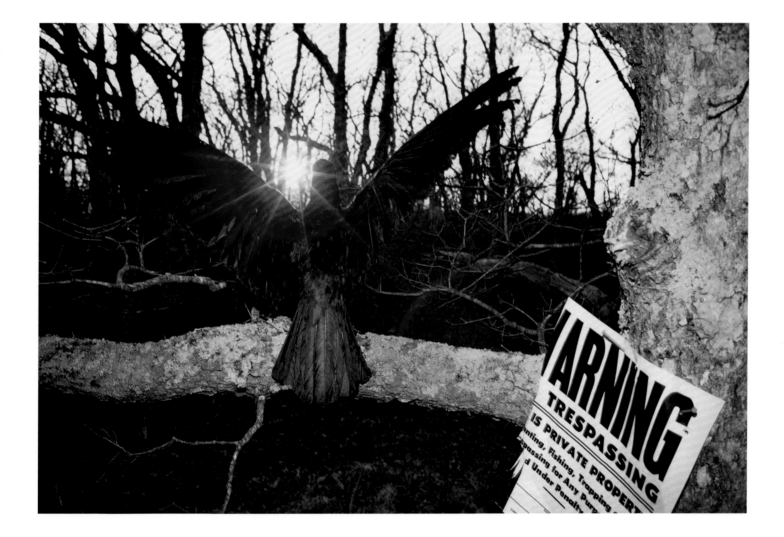

1986
_____
Brown horse and car

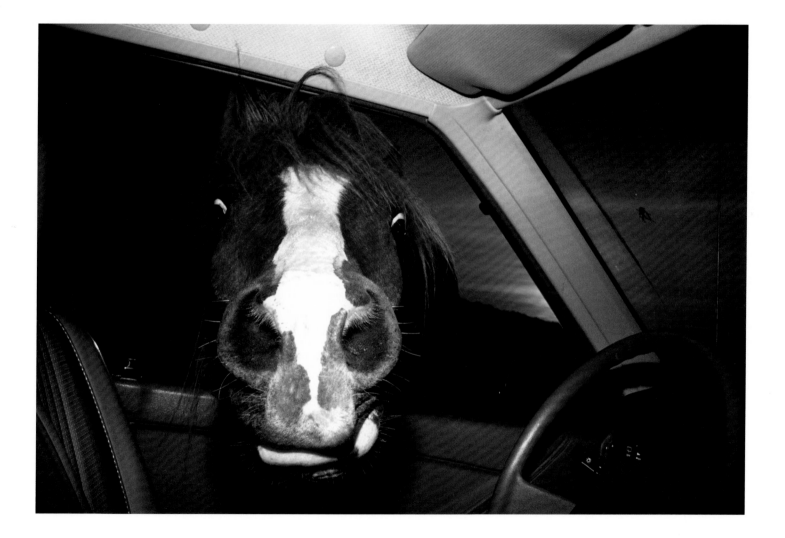

1985
_____

Ruffed grouse and dressmaker's form at Black Point Pond

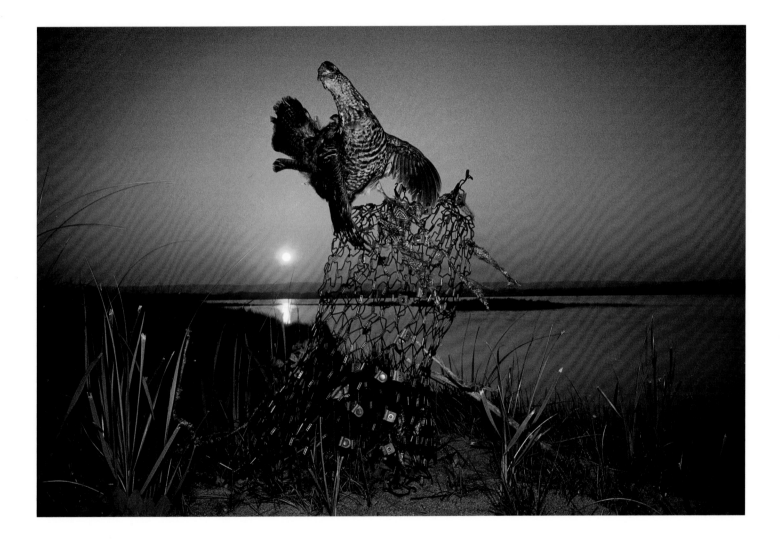

1986
—————

Opossum and heart at Black's Nook Pond

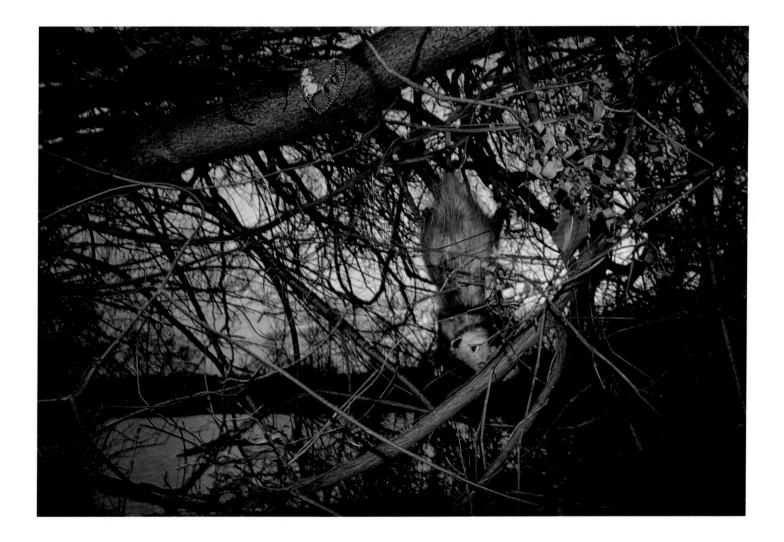

1986

Immature mute swan and Coke can on Swan Pond

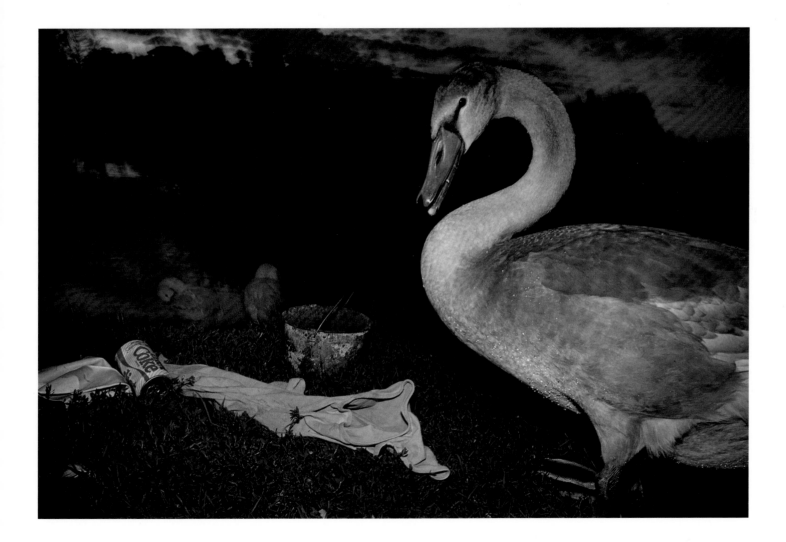

1986
_____
Raccoon and pill bottles

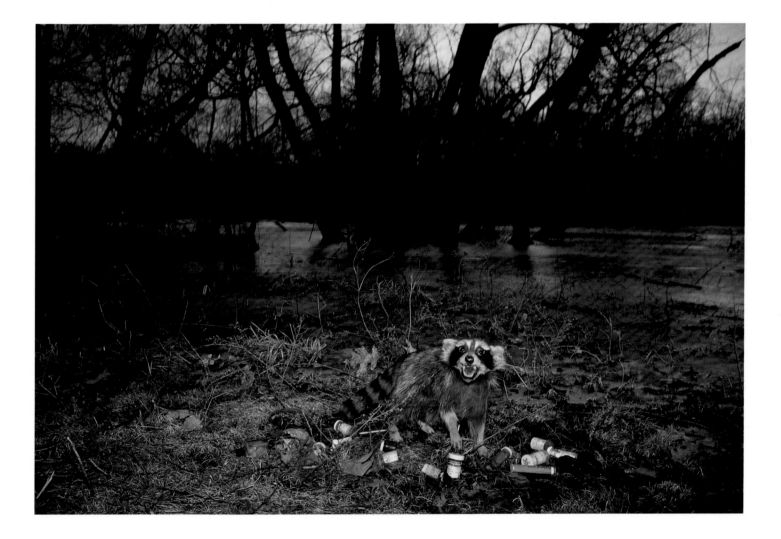

1986
_____

Ruffed grouse and abandoned house

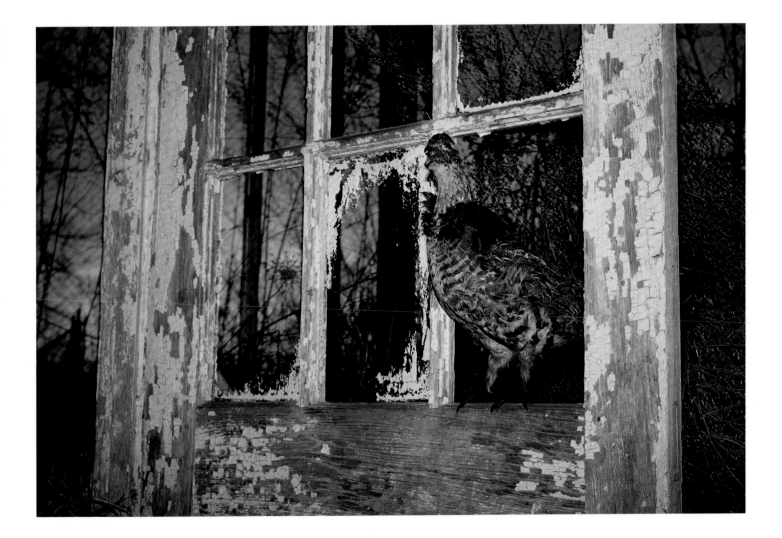

1984
---

American crow and abandoned shack on Great Pond

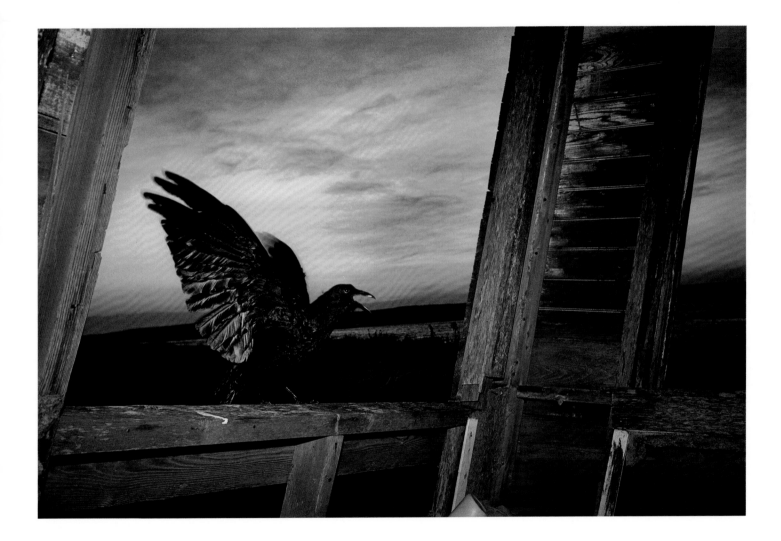

1988
_____

**Woodchuck and abandoned office furniture**

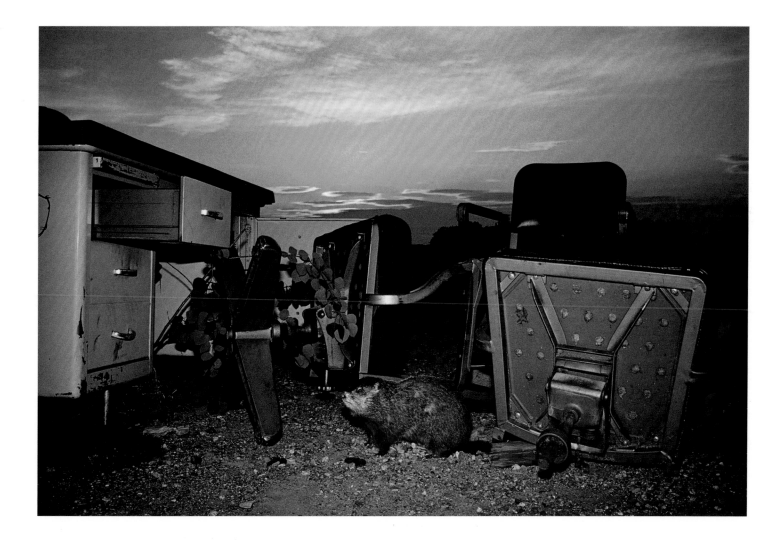

1985
_____
Norway rat and toy truck

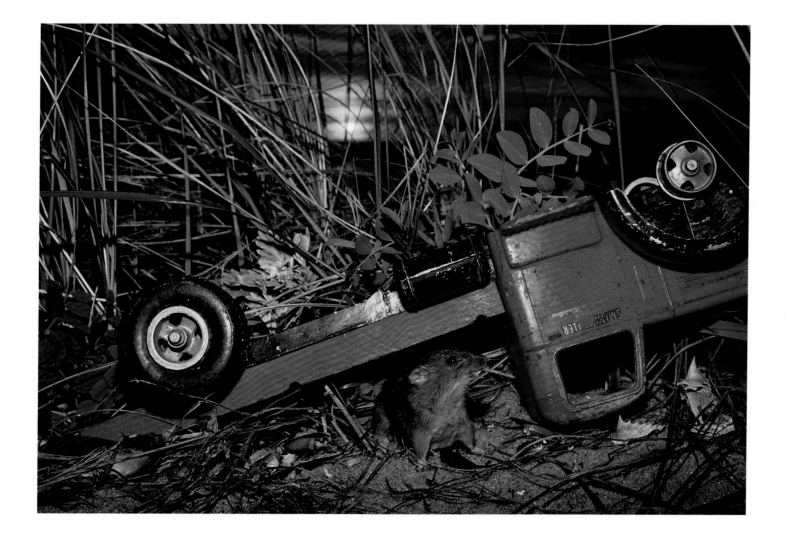

**1985**

Raccoon and wrecked car

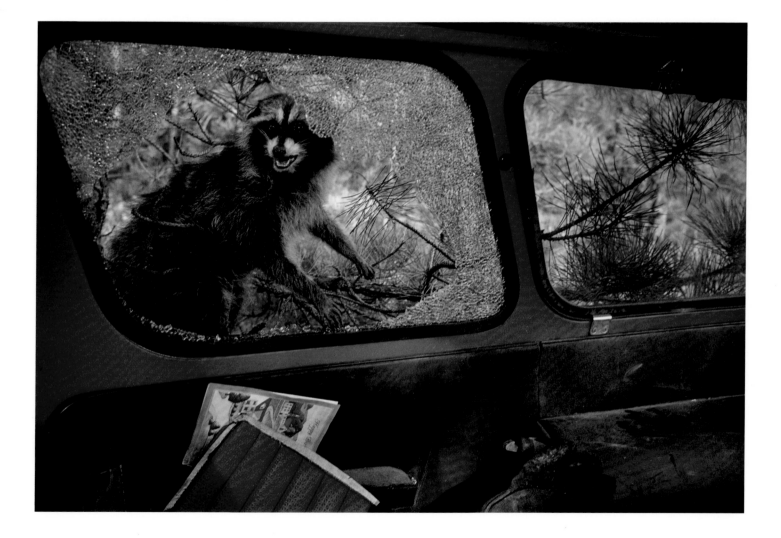

1985
_____
Blue jay and wrecked car

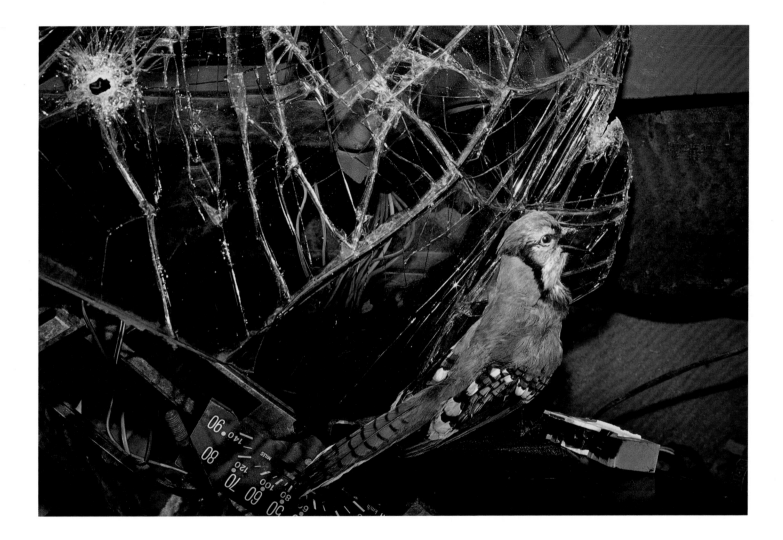

1986

Eastern cottontail and wrecked car

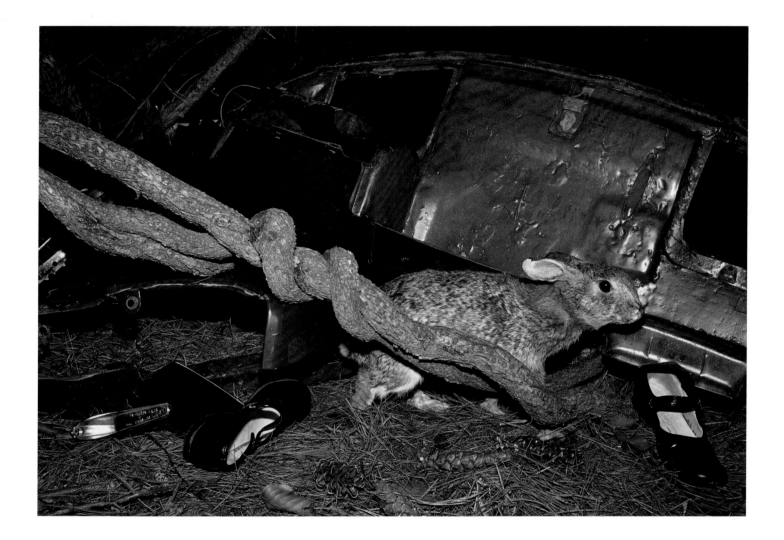

1986
_____

American crow and overturned truck

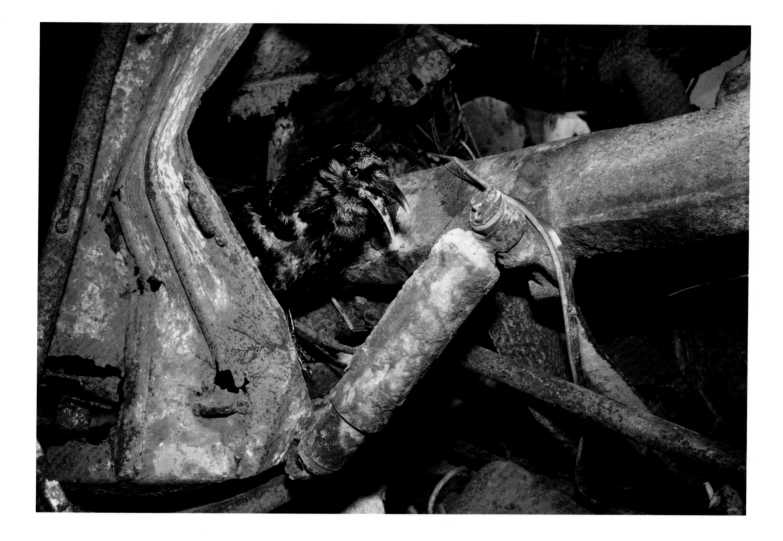

1986
_____
Red fox in abandoned greenhouse

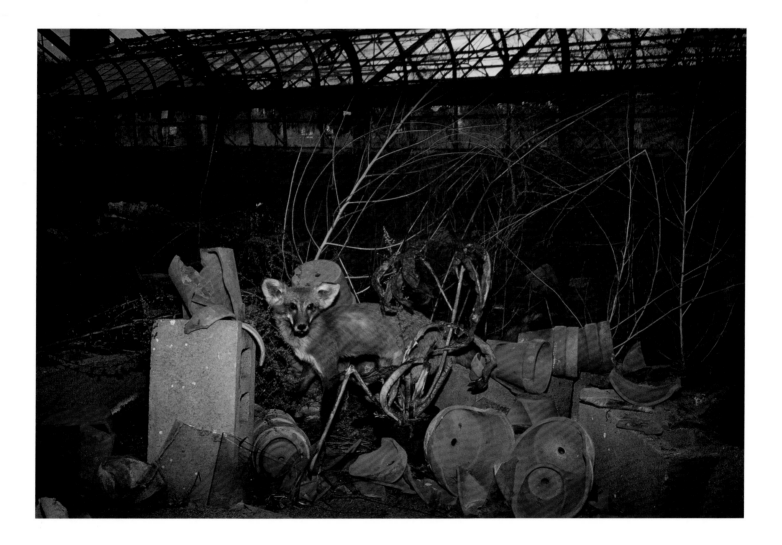

1986
_____
Dog and water pipe debris

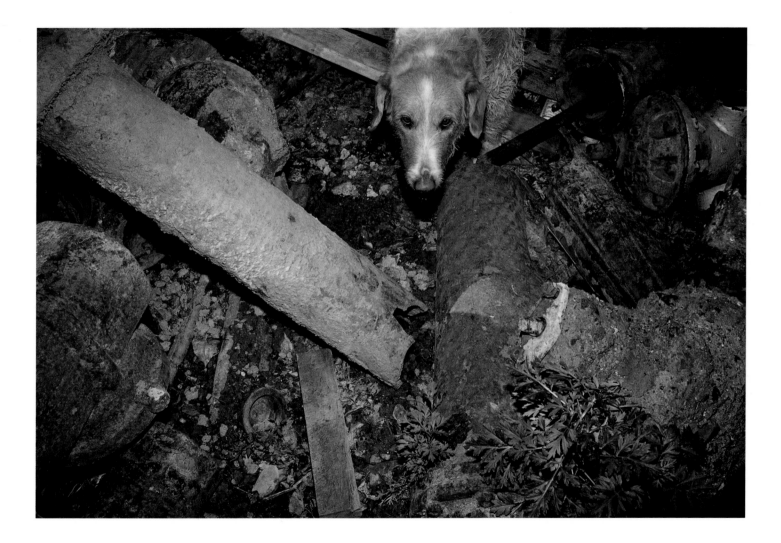

1988
_____

Skunk and fire hydrant

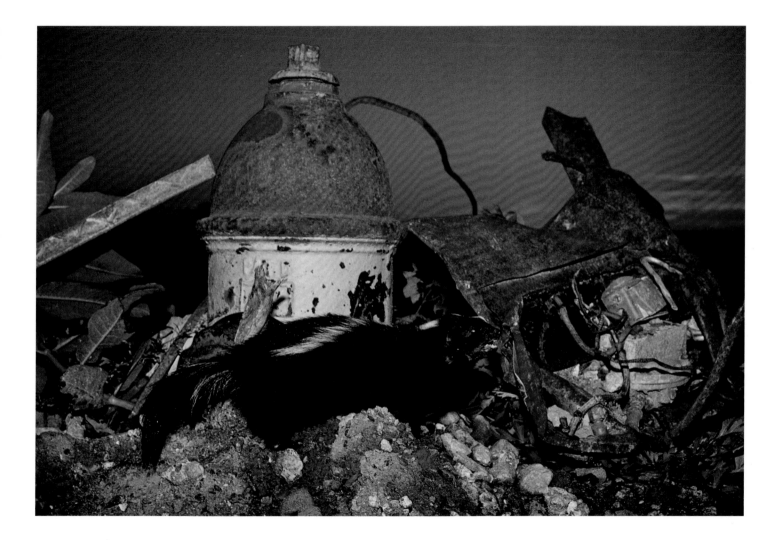

1987
_____

Muskrats and fishermen's flotsam

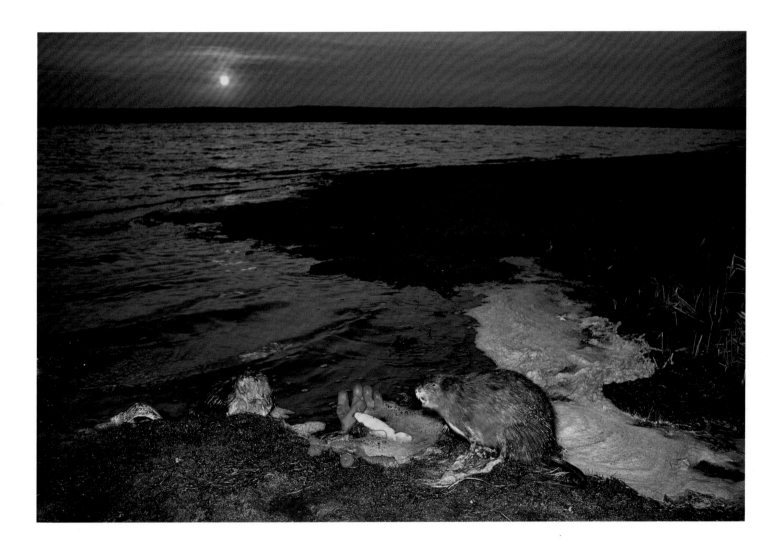

1988
——————
Eel and jacket in Great Pond

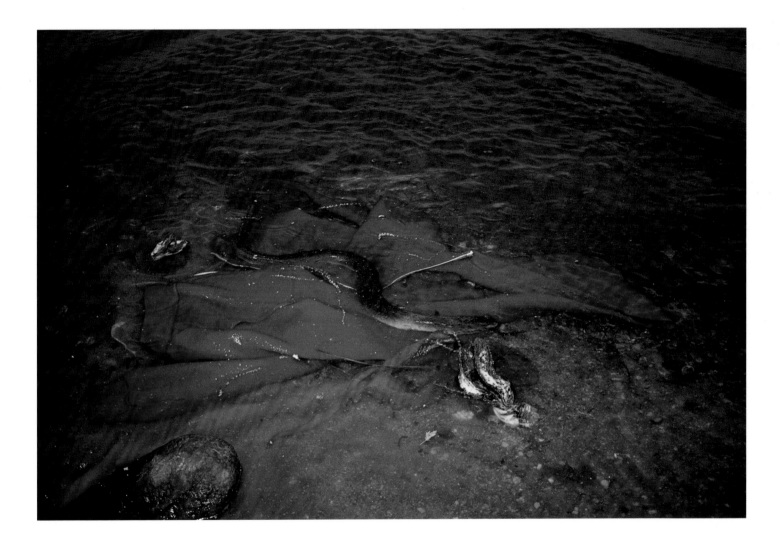

1985
_____

Eastern gray squirrel on windshield

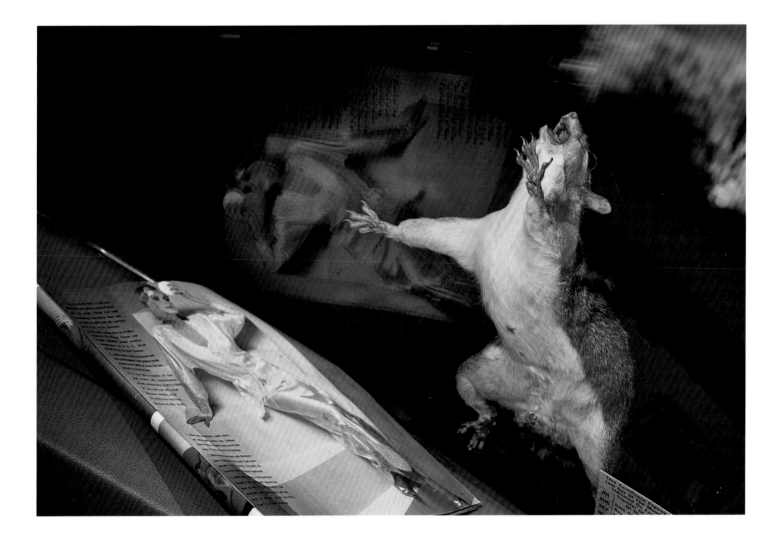

**1985**

Herring gull and truck hood ornament in Great Pond

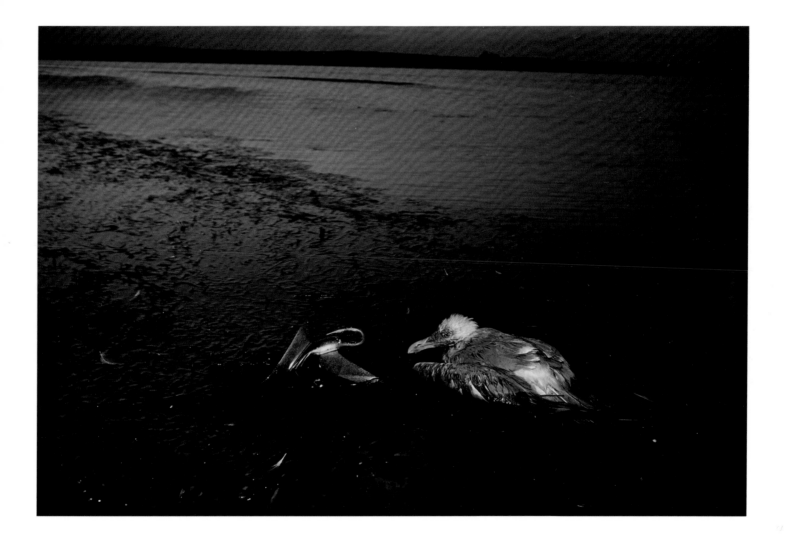

1988
_____

Grass frogs and playing cards

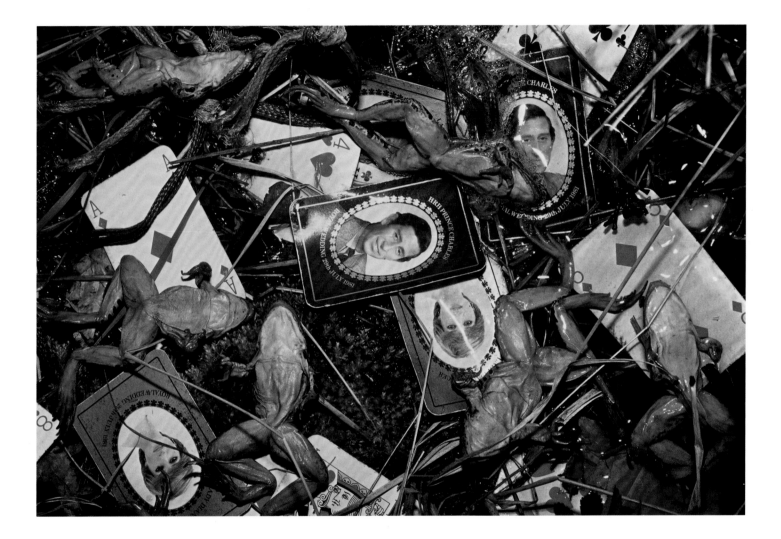

1984
_____

Catbird and bedspring debris

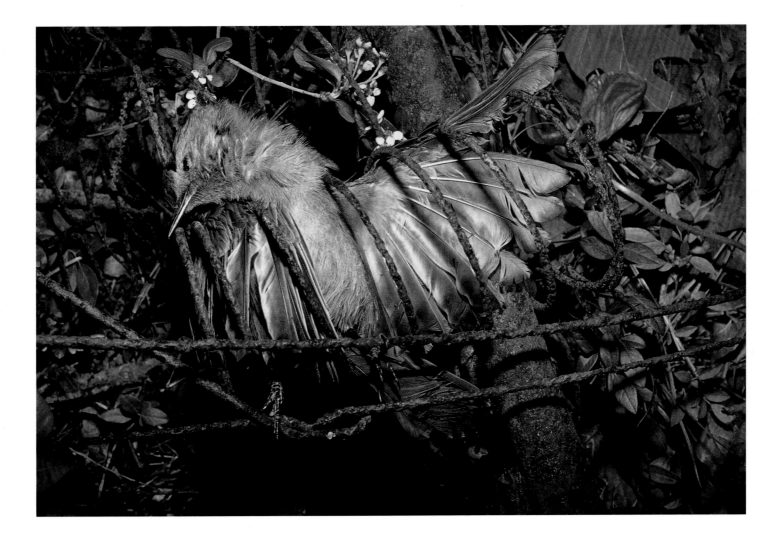

Editor: Robert Morton
Designer: Maria Miller

Front cover: *Racoon and wrecked car,* 1985
Back cover: *Barbara Norfleet and Peaches,* 1989
  (Photograph by Roswell Angier)

Library of Congress Cataloging-in-Publication Data

Norfleet, Barbara P.
  Manscape with beasts: photographs/by Barbara Norfleet.
    p.   cm.
  ISBN 0-8109-2444-7
  1. Photography of animals.   I. Title.
TR727.N67   1990
779'.32 — dc20                    89-39210

Copyright © 1990 Barbara Norfleet
Published in 1990 by Harry N. Abrams, Incorporated, New York
A Times Mirror Company
Printed and bound in Japan